Bird Watching

Bird Watching

Paula McCartney

Princeton Architectural Press, New York
The Museum of Contemporary Photography at Columbia College Chicago

Published by
Princeton Architectural Press
37 East Seventh Street
New York, New York 10003

For a free catalog of books, call 1.800.722.6657.
Visit our website at www.papress.com.

The Museum of Contemporary Photography at Columbia College Chicago
600 S. Michigan Ave.
Chicago, IL 60605

Paula McCartney's *Bird Watching* series has been included in the Midwest
Photographers Project at the Museum of Contemporary Photography at Columbia College
Chicago since 2005. The Midwest Photographers Project supports emerging and
established artists from nine midwestern states by making their work accessible to
students, curators, collectors, and the general public—online, in our print study
room, and by supporting first publication projects.

Editor: Nicola Bednarek
Design: Based on Paula McCartney's artist book *Bird Watching*
Layout: Bree Anne Apperley
Cover design: Deb Wood

Special thanks to: Nettie Aljian, Sara Bader, Janet Behning, Becca Casbon, Carina
Cha, Penny (Yuen Pik) Chu, Carolyn Deuschle, Russell Fernandez, Pete Fitzpatrick,
Wendy Fuller, Jan Haux, Clare Jacobson, Aileen Kwun, Nancy Eklund Later, Linda
Lee, Laurie Manfra, John Myers, Katharine Myers, Lauren Nelson Packard, Dan Simon,
Andrew Stepanian, Jennifer Thompson, Paul Wagner, Joseph Weston, and Deb Wood of
Princeton Architectural Press —Kevin C. Lippert, publisher

Library of Congress Cataloging-in-Publication Data
McCartney, Paula.
 Bird watching / Paula McCartney.
 p. cm.
 "Paula McCartney's Bird watching series has been included in the Midwest
Photographers Project at the Museum of Contemporary Photography at Columbia
College, Chicago since 2005."
 ISBN 978-1-56898-855-9 (alk. paper)
1. Photography of birds. 2. Birds—Models—Pictorial works. 3. Landscape
photography. I. Columbia College (Chicago, Ill.). Museum of Contemporary
Photography. II. Title.
 TR729.B5M425 2010
 779.328—dc22
 2008054611

Contents

(Non) Flights of Fancy

In the last sentence of her *Bird Watching* journal, Paula McCartney refers to her project as the result of a "three-year collaboration with the natural world." Yet, despite the book's title, the natural world she collaborates with does not include real birds. The landscape serves as her inspiration, and she activates it by adding synthetic decorative birds that she buys at craft stores and on eBay. In the notes that accompany the book's photographs, McCartney describes her observations of the passerines, or perching birds, as well as her travels over the course of three winters, to locations including Hawaii, Kansas, Michigan, Oregon, and Minnesota. Part document and part fiction, this fanciful, homespun field guide is an engaging blend of personal recollection and reverie.

While the pristine natural settings McCartney photographs are already picturesque, she was looking for something more: "I wanted to make the landscapes more romantic, more idyllic," she explains. Like many painters throughout history, McCartney creates fictions at will, and uses birds as symbolic, beautiful elements within a controlled composition. And like the doves who repair Cinderella's dress in Walt Disney's movie, her passerines are friendly, feel-good additions to the landscape. McCartney's pictures reveal a strong need for the fulfillment of an ideal. In this respect they call forth broader issues concerning our relationship to nature and wildlife: What are our expectations when we approach the natural landscape? Are we always waiting for certain romantic experiences to punctuate our wandering, such as a deer running by or a perfect snowflake landing on our mittens? To what extent are we trying to satisfy a preexisting image of nature that we carry in our minds? And what role does photography play in fixing these images and desires in our consciousness?

Our complicated relationship with nature and our need to control it in search of an unattainable ideal are long-standing concerns for McCartney. Prior to *Bird Watching* she created a series of gelatin silver

photographs of zoological habitats called *Bronx Zoo* (1997–98). The series captures real foliage and birds in small cells whose back walls are painted with typical perspective-drawing landscape scenes. The dioramas are weak approximations of nature, but in some of McCartney's pictures the black-and-white film strengthens their illusion by equalizing the real and artificial elements. Other images in the series disrupt this view by revealing structural elements of the zoo buildings, such as windowpanes and ceiling beams. Taken as a whole, the series effectively addresses the complicated nature of these environments—they provide us with a convenient, entertaining, and potentially educational experience, yet they do so by creating a mediated, false view of nature that is far different from the experience of being out in the wild.

In *Bird Watching* McCartney reverses the *Bronx Zoo* project's strategy by populating a natural habitat with artificial wildlife. Her work is the exact opposite of that of amateur ornithologists, who carry large cameras with telephoto lenses into the woods and wait patiently to capture a decent image of a bird. McCartney skirts the inconvenience of waiting and opts for instant gratification. She allows, however, for her viewer to become engaged by placing the bird models at a distance from her lens, inviting believability but also allowing the viewer to notice, upon closer observation, the wires that secure the birds in position. Once this realization occurs, the texts, diagrams, and drawings of *Bird Watching* all become artificial. They also reveal McCartney's sense of humor. Reading statements like, "By now I have gotten so comfortable approaching the birds, they seem to hold their poses for me as long as I need them to in order to make their portraits," it is difficult not to take pleasure in the sheer eccentricity of it all.

In this way, McCartney's work seems to take some cues from John James Audubon, the father of ornithological illustration, who was notorious for his drive to document every bird in North America and for

stretching the truth about both his own life story and his encounters with nature.[1] In McCartney's project there are no clear lines between fact and fiction. Like James Casebere or Oliver Boberg's photographs of constructed models that at first glance appear to be real architectural spaces, she exploits the believability of photography and at the same time invites a mistrust of photographic evidence. When we read a simple account of events accompanied by photographic documentation, we tend to believe the writing describes what we see, and what we see illustrates the writing. Using photography to give evidence of something that is pure fiction, McCartney's field guide journal sets up a good-natured game that invites complicity.

To enjoy her work at its fullest is to allow one's imagination to run wild, to follow McCartney's adventures and psychological twists and turns, and to consider her quest for the ideal photograph. Her ultimate goal seems to be to cause the viewer to detect a desire for something more on the part of the author, beyond just a humorous, compulsive need to record nature. There is also evident a longing for a more meaningful, enriched experience of the world as it is. This romantic impulse to delight in beauty and discovery is something we can all, undoubtedly, relate to.

Karen Irvine
Curator, Museum of Contemporary Photography
Columbia College Chicago

[1] For many examples of exaggeration and assumed half-truths in Audubon's writings, see Ella M. Foshay, *John James Audubon*, Chapter III, "Entrepreneur and Writer" (New York: Harry N. Abrams, Inc., in association with The National Museum of American Art, Smithsonian Institution, 1997), 66–93.

You have now before you representations of some of the most richly colored of our birds, and one(s) whose history is in some degree peculiar.

John James Audubon, *Ornithological Biography*

Bird Watching

Name	NORTHERN CARDINAL
Location	Southern Oregon coast
Date	June 2006
Size	8.75 inches
Coloring	Bright red overall
Remarks	The only red bird with a crest

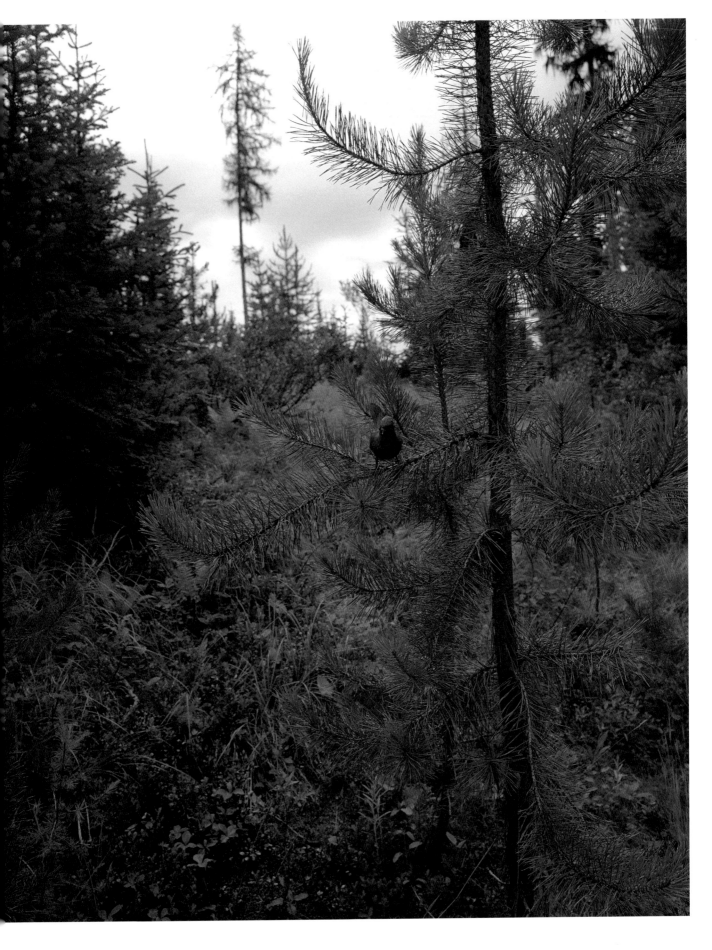

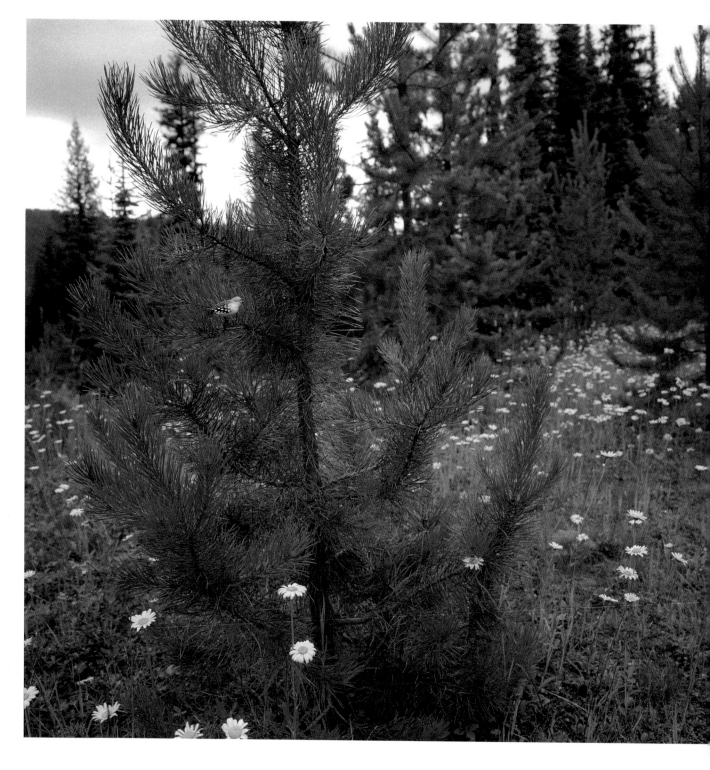

Name	SPOTTED WREN
Location	Southern Oregon coast
Date	June 2006
Size	4.5 inches
Coloring	Golden crown, spotted back and wings
Remarks	A field of daisies was the perfect backdrop for this little bird.

Name	WESTERN BLUEBIRD
Location	Glacier National Park, MT
Date	July 2006
Size	7.5 inches
Coloring	Dark blue head, orange breast
Remarks	Western Bluebirds have twice the girth as their eastern cousins.

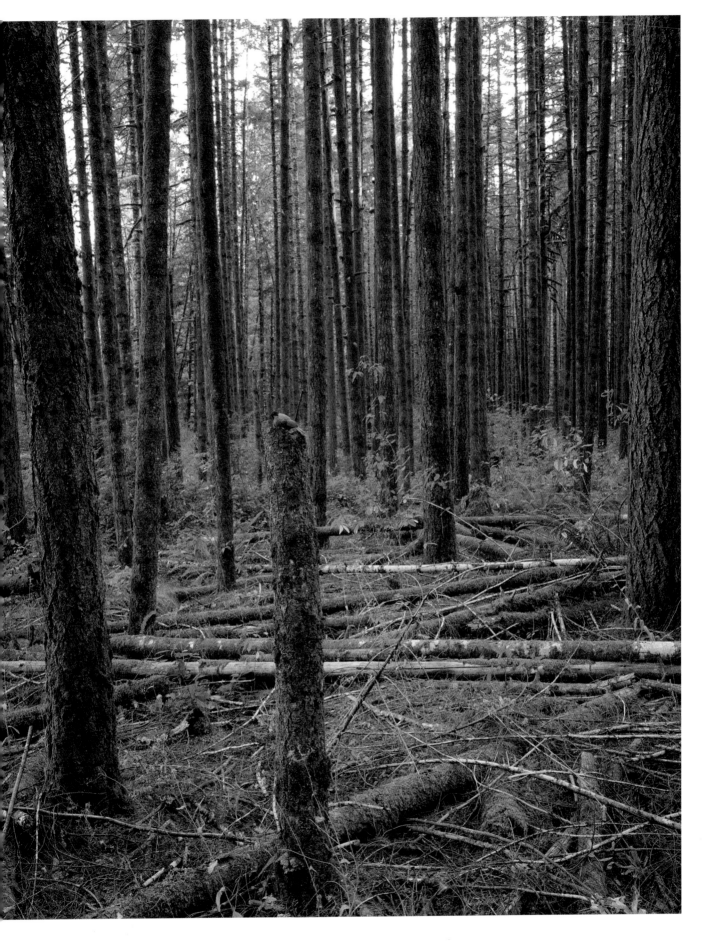

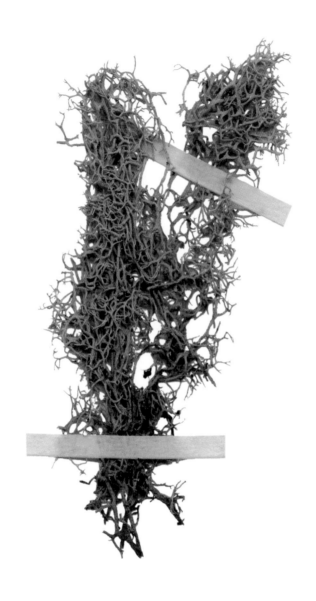

Moss specimens found in the woods by the Western Bluebird

Name	BLACK-CAPPED CHICKADEE
Location	San Francisco, CA
Date	September 2006
Size	4.5 inches
Coloring	Black crown and back, orange belly
Remarks	A juvenile bird perched atop a branch

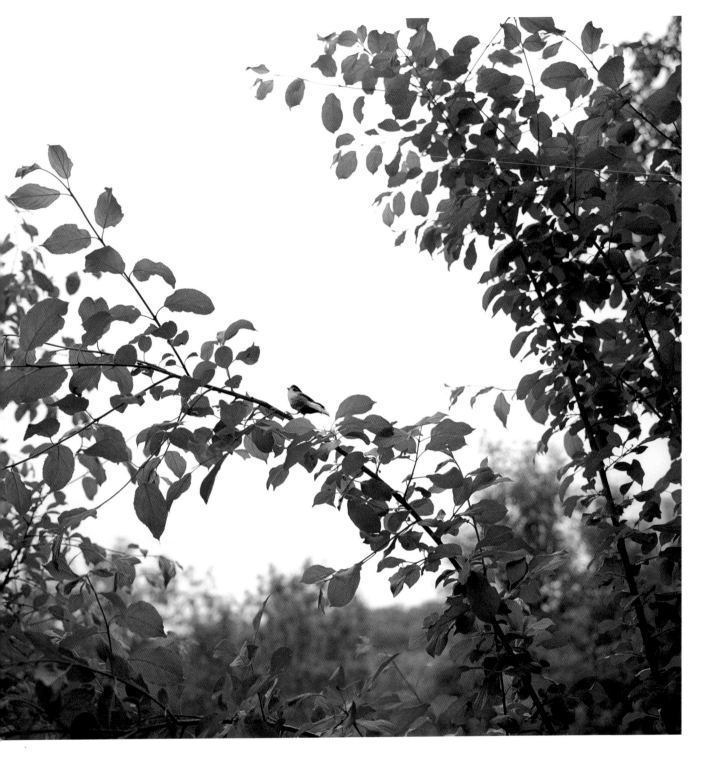

Name	GRAY-HEADED CHICKADEES
Location	San Francisco, CA
Date	September 2006
Size	5.5 inches
Coloring	Gray crowns, pale backs and belly feathers
Remarks	These hearty birds grew plump from a summer of plentiful insects.

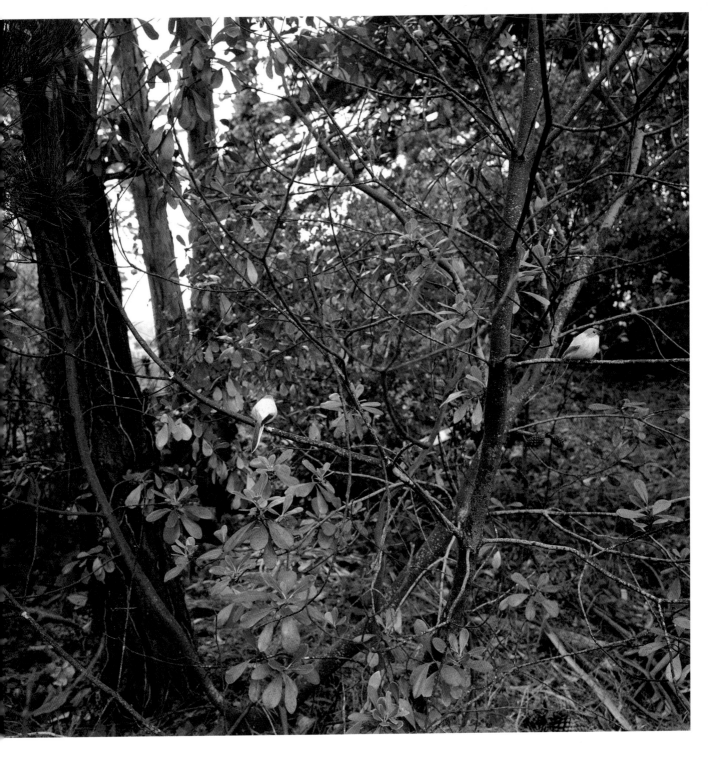

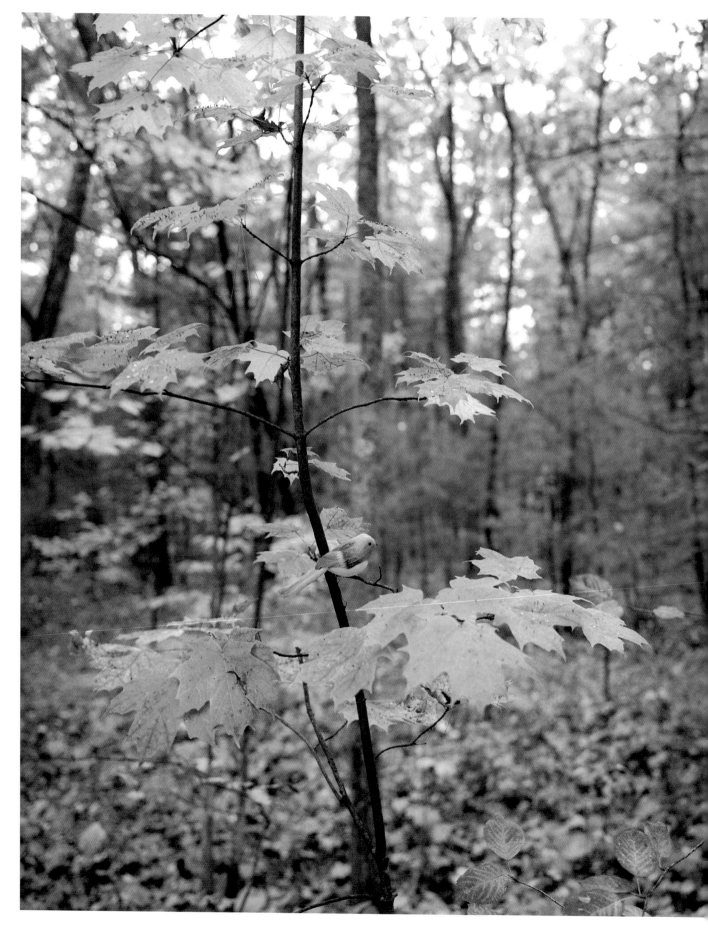

Name	ORANGE-THROATED PHOEBE
Location	Interlochen, MI
Date	October 2006
Size	7.5 inches
Coloring	Sky-blue crown, orange throat
Remarks	Their coloring blends with the fall foliage.

Orange leaves collected
in the park where I spotted
the Orange-throated Phoebe

Name	CHESTNUT-BACKED CHICKADEES
Location	Interlochen, MI
Date	October 2006
Size	5.25 inches
Coloring	Brown heads with warm chestnut backs
Remarks	The birds were unaware as I approached them.

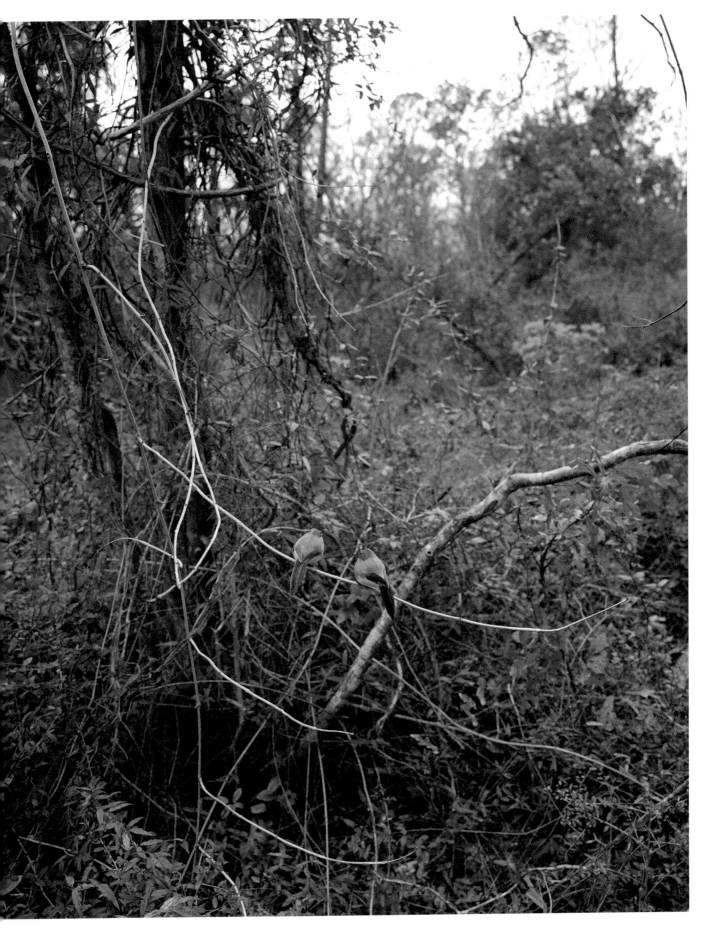

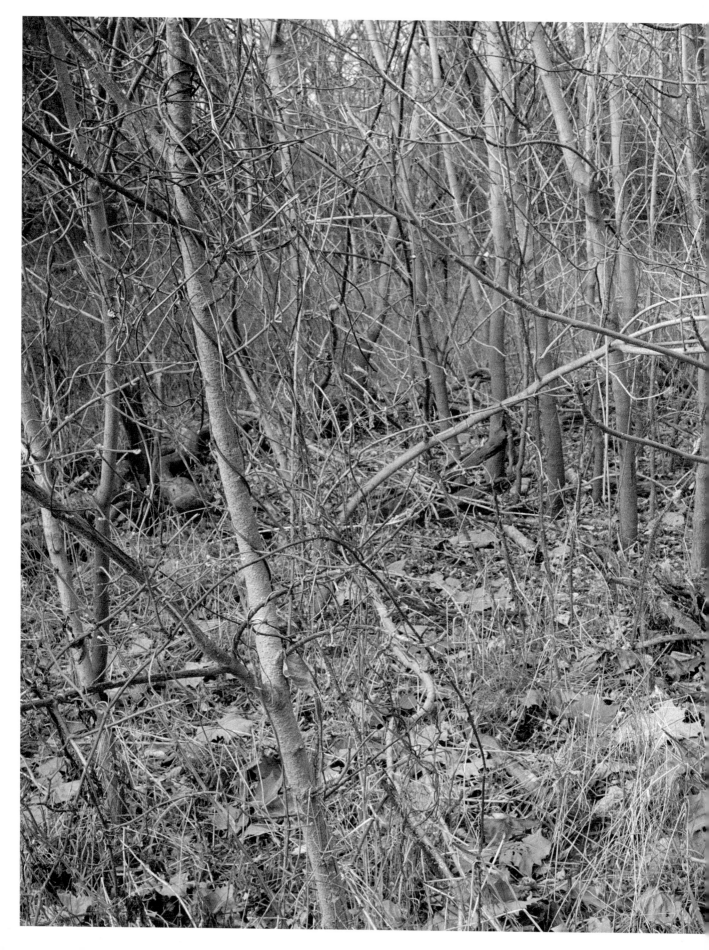

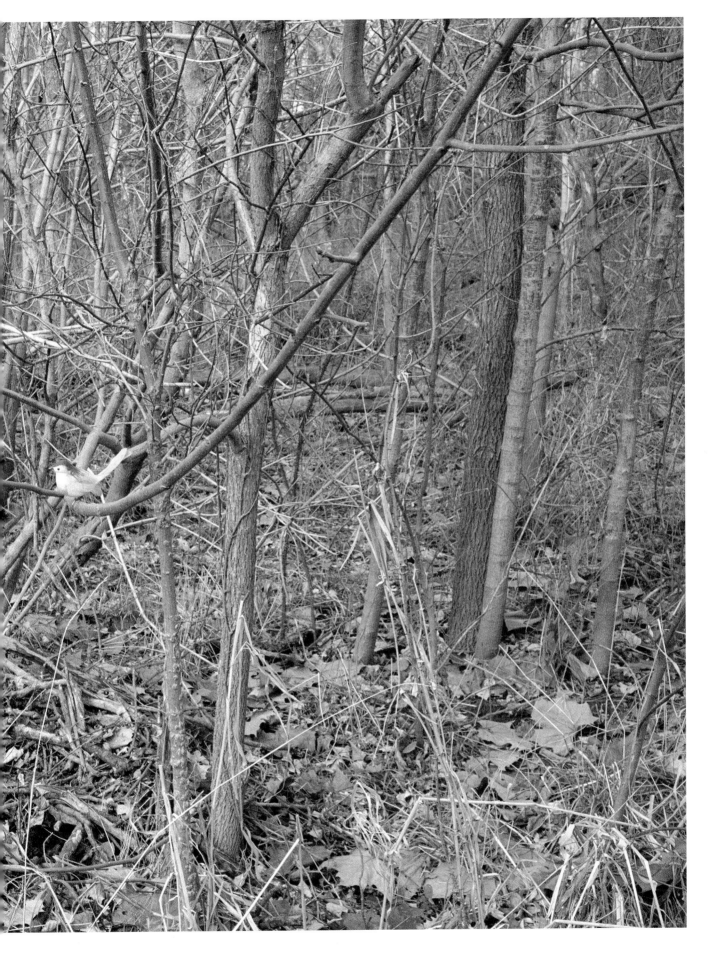

previous page

Name	PINK-TAILED GNATCATCHER
Location	Olathe, KS
Date	November 2006
Size	5 inches
Coloring	Rust-colored crown, pink tail
Remarks	The raised tail signals alertness to my presence.

Name	DARK-EYED JUNCO
Location	Olathe, KS
Date	November 2006
Size	6.25 inches
Coloring	Dark gray hood, blue body
Remarks	This curious bird investigates the tangled milkweed pods.

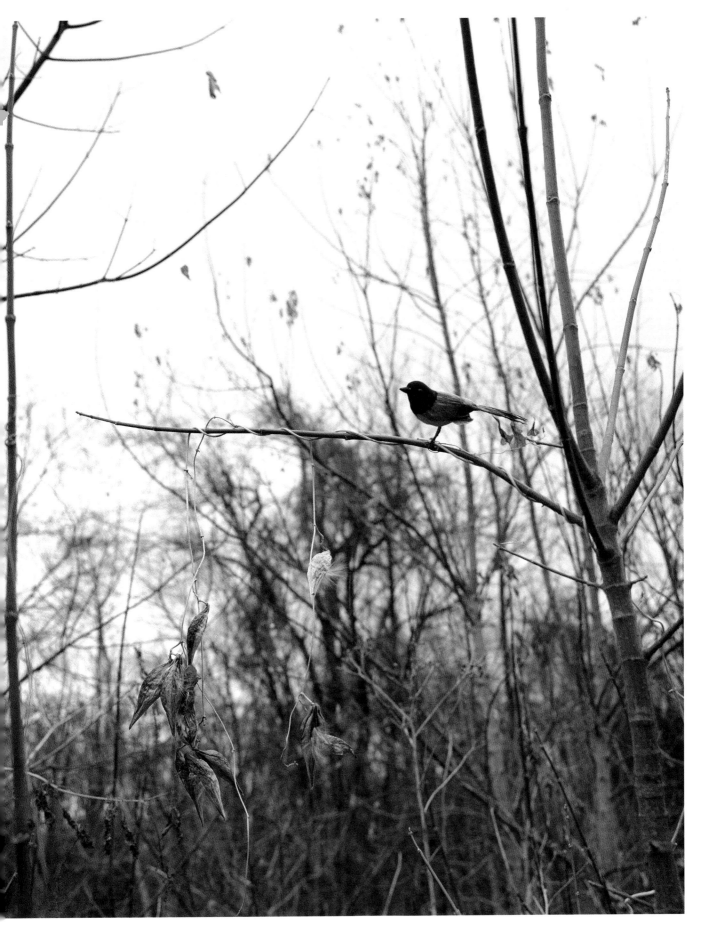

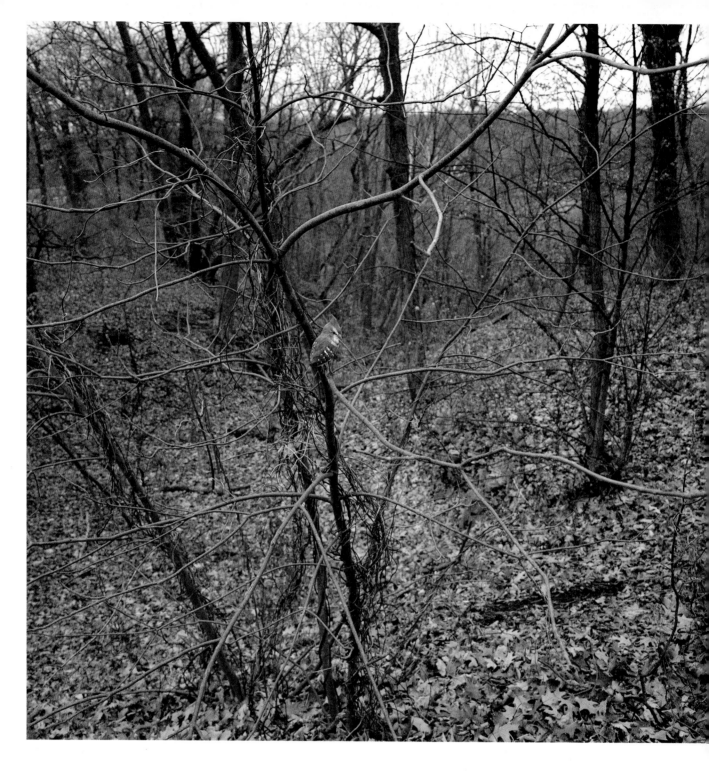

Name	BLUE JAY
Location	Interlochen, MI
Date	November 2006
Size	10 inches
Coloring	Gray eye band, large spots on wings
Remarks	This jay is so plump, could it be a new subspecies?

Name	SONG SPARROW
Location	Interlochen, MI
Date	December 2006
Size	6.25 inches
Coloring	Black and white spots on the breast
Remarks	Ready to take flight from the snowy winter landscape

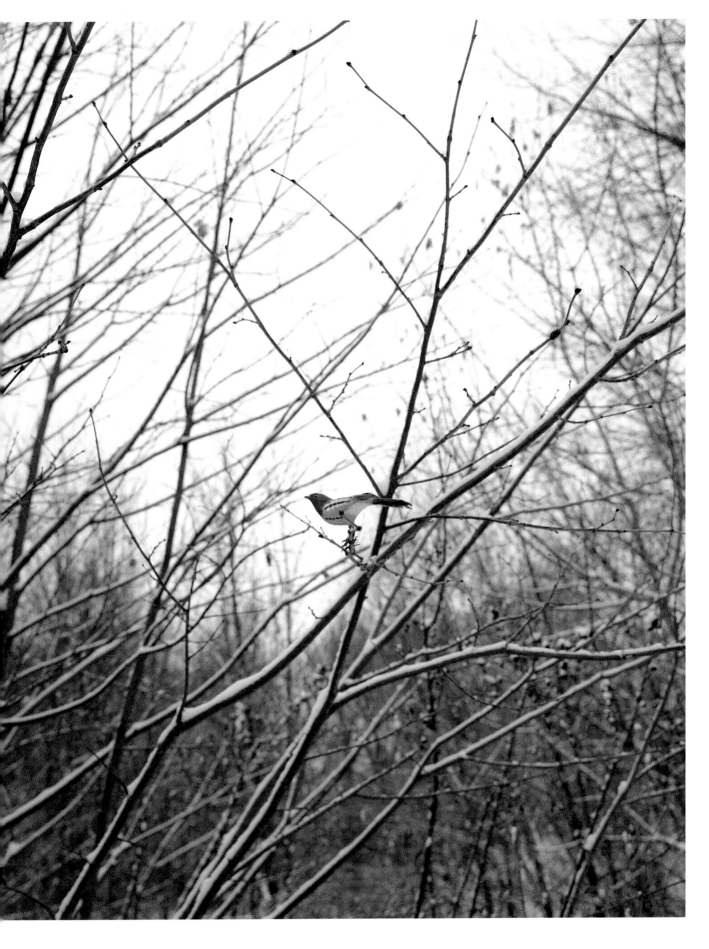

Notes: <u>Winter 2006</u>

<u>I began this collection in the summer on a</u>
<u>road trip from my home in SanFrancisco up</u>
<u>along the Oregon coast. Having stopped</u>
<u>to take a walk in the woods, I spotted a</u>
<u>Northern Cardinal and was instantly</u>
<u>attracted to how the bright red bird</u>
<u>contrasted richly with the dense, green woods.</u>
<u>I loved how it was posed just so and was</u>
<u>compelled to photograph it. Later that</u>
<u>day I documented another bird, a Spotted</u>
<u>Wren, perched in a pine tree surrounded</u>
<u>by daisies.</u>

<u> I was enthralled by the resulting images</u>
<u>from my trip and decided to keep this</u>
<u>journal to record the different birds in</u>
<u>their varied environments, both at home</u>
<u>and on travels. I realized I'm not content</u>
<u>to only briefly view the birds in their</u>
<u>habitats but want to document them, so</u>
<u>I can continuously revisit these idealized</u>

scenes. These experiences are a much-needed respite from the craziness of the city. In the woods, with the birds, I sense a unique balance.

In the fall we moved to Interlochen, Michigan. It is aptly named, situated between two lakes. It's the smallest town I've ever been to, but our cabin is in the middle of the woods, so there will be many opportunities to photograph the birds.

Back in Kansas to visit my parents for Thanksgiving, I saw interesting birds along a creek. No snow had fallen yet, so there were many clear days. In December, after all the leaves had fallen, I spotted the fattest Blue Jay I had ever seen, perched in a tree along one of the lakes. He is sure to make it through the winter with all his reserves.

Name	GREEN-CAPPED BUNTINGS
Location	Interlochen, MI
Date	January 2007
Size	5.5 inches
Coloring	Green backs, yellow breasts
Remarks	Sitting still on a branch after another snowfall

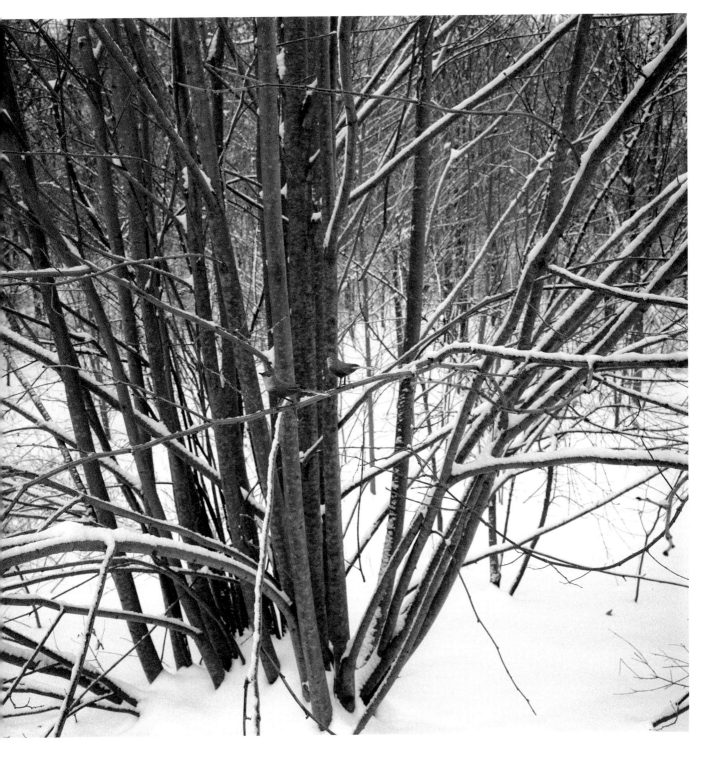

Name	BLUE-HOODED CUCKOO
Location	Interlochen, MI
Date	March 2007
Size	10 inches
Coloring	White beak and dark blue head
Remarks	Sleek and good-looking

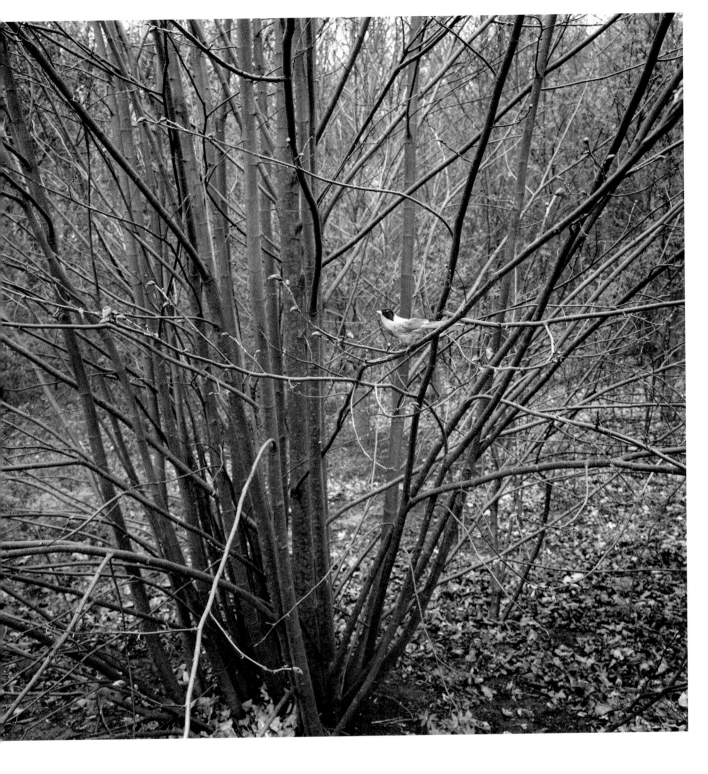

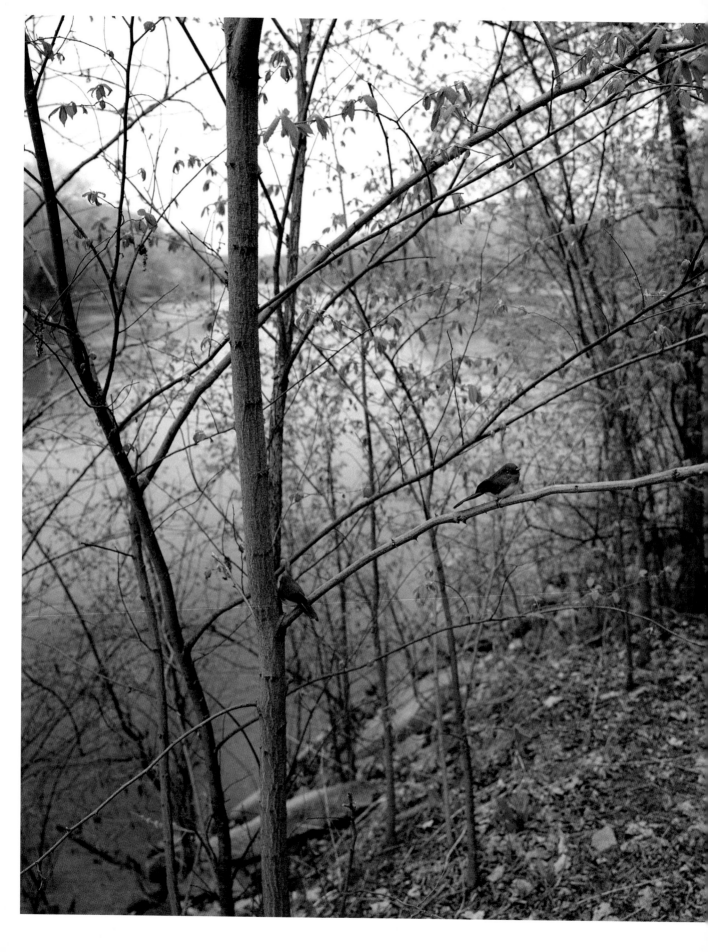

Name	VERMILION FLYCATCHERS
Location	Interlochen, MI
Date	April 2007
Size	6 inches
Coloring	Bright red bodies and yellow bellies
Remarks	Enjoying the view by the lake

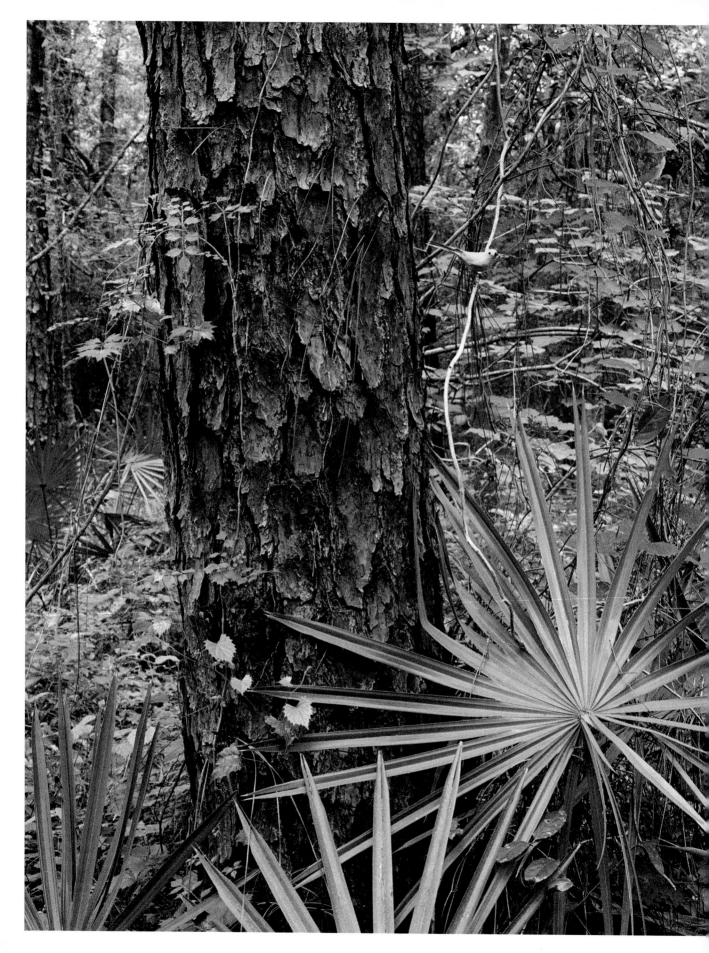

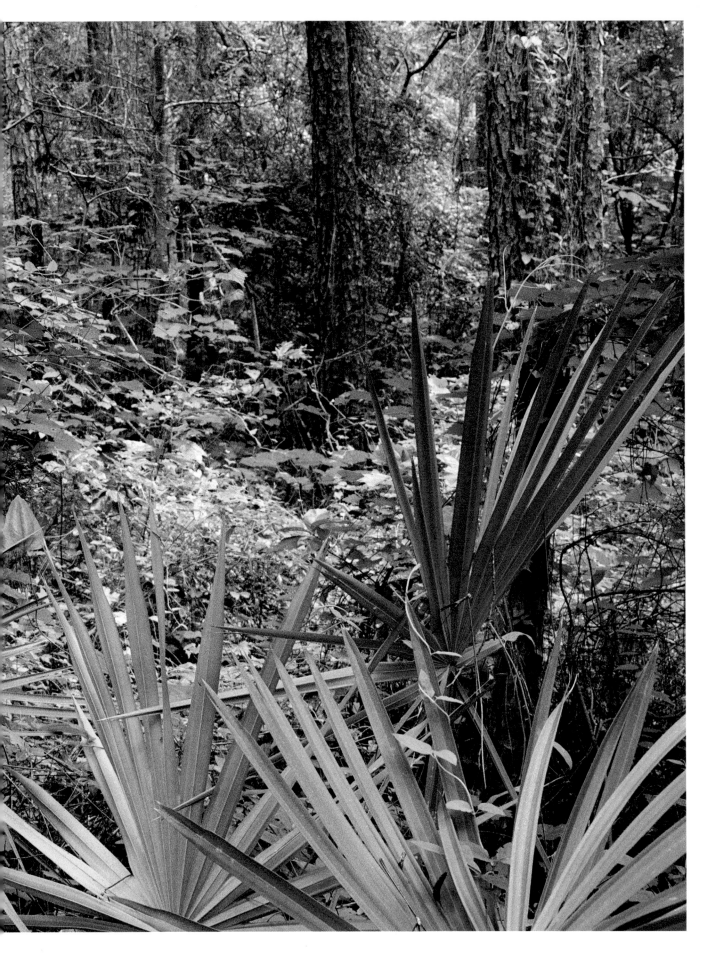

previous page

Name	YELLOW WARBLER
Location	Charleston, SC
Date	June 2007
Size	6 inches
Coloring	Yellow body and black tail feathers
Remarks	The green palmettos offer no camouflage for the shy bird.

Name	CALIFORNIA WREN
Location	Marin Headlands, CA
Date	July 2007
Size	5.5 inches
Coloring	Red crown, white beak
Remarks	This wren grew plump on summer fennel.

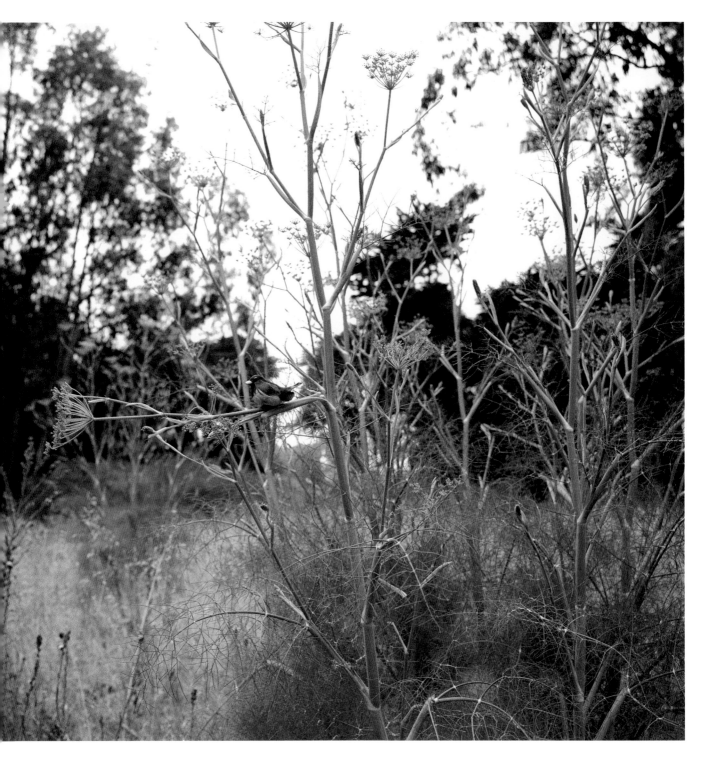

Name	GRASSLAND SPARROW
Location	Sonoma, CA
Date	July 2007
Size	6 inches
Coloring	Gray crown and white wing bands
Remarks	The sparrow's flank feathers grow dense in the summer.

Queen Anne's Lace (Wild Carrot)

The plant's common name, Bird's Nest,
comes from its resemblance to
dried-up flower heads.
It thrives in summer fields.

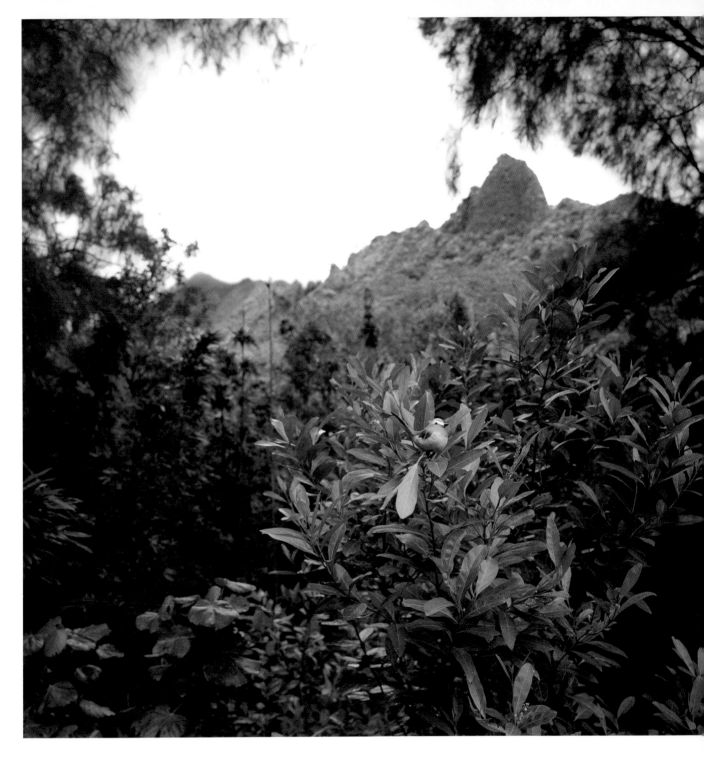

Name	PACIFIC MOCKINGBIRD
Location	Pali Lookout, Oahu, HI
Date	July 2007
Size	8 inches
Coloring	White eye band, blue body
Remarks	The bird came out to look around between rain showers.

Name	TROPIC WARBLERS
Location	Volcano Village, HI
Date	July 2007
Size	4.25 inches
Coloring	White bodies, red beaks
Remarks	The birds look so small next to giant tree ferns.

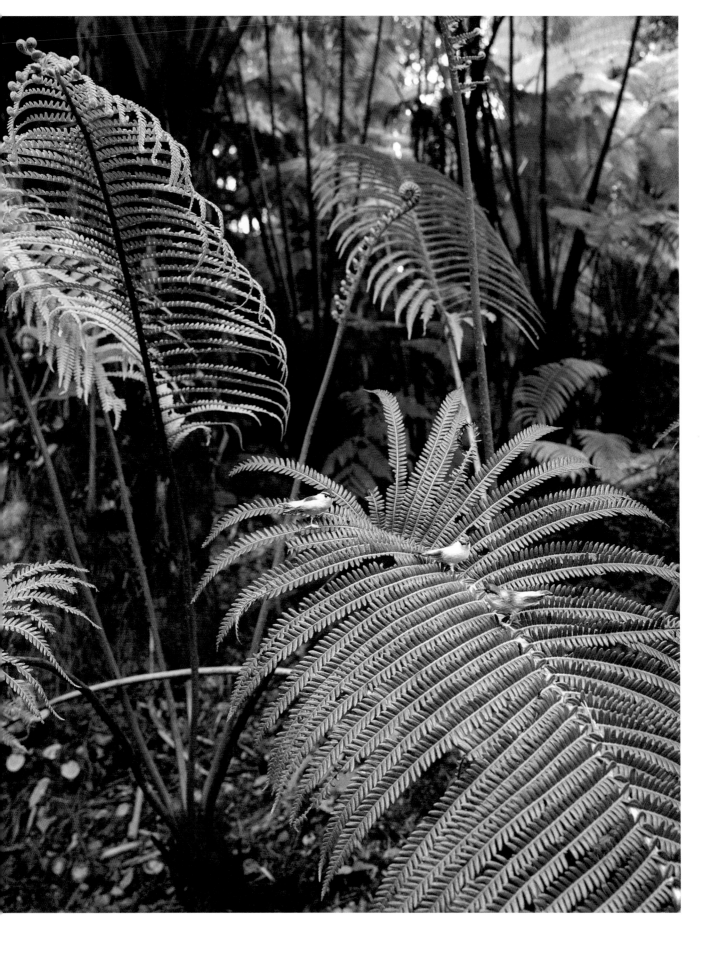

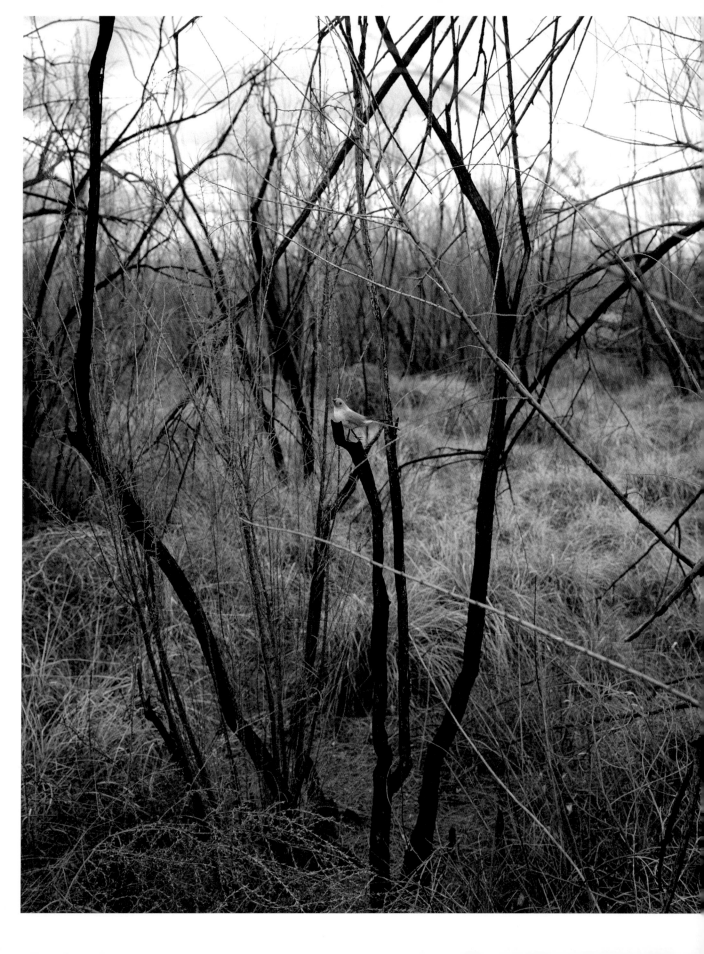

Name	ORANGE THRUSH
Location	Albuquerque, NM
Date	August 2007
Size	7 inches
Coloring	Orange head and back, brown tail feathers
Remarks	The bright orange feathers reflect the flames that burned this bosque.

Name	BARN SWALLOWS
Location	Ithaca, NY
Date	November 2007
Size	6.5 inches
Coloring	Blue backs, long tail feathers
Remarks	Both birds elegantly turn their heads toward the camera.

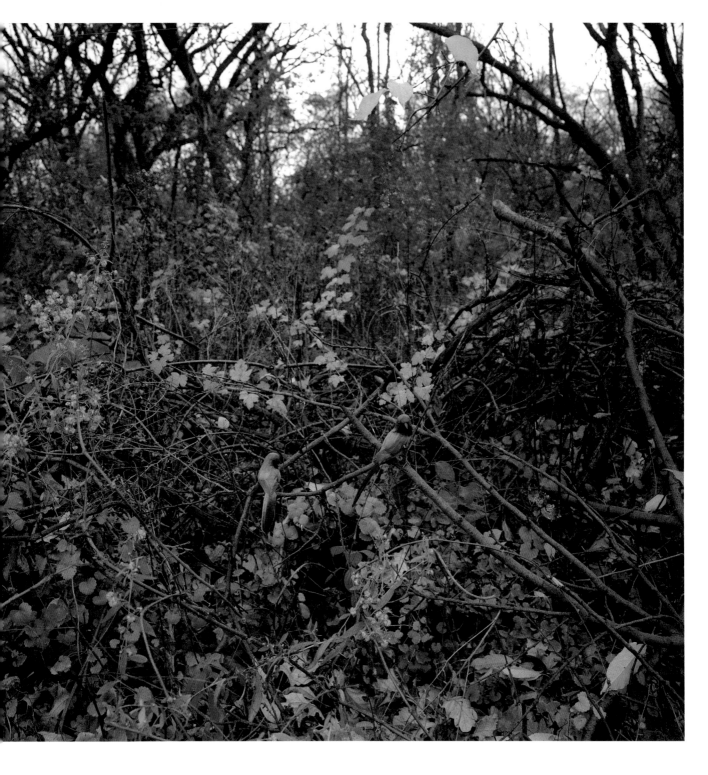

Name	NORTHERN VIREO
Location	Syracuse, NY
Date	November 2007
Size	5 inches
Coloring	Light-colored beak, brown body
Remarks	Briefly sighted perched on a branch in a state park

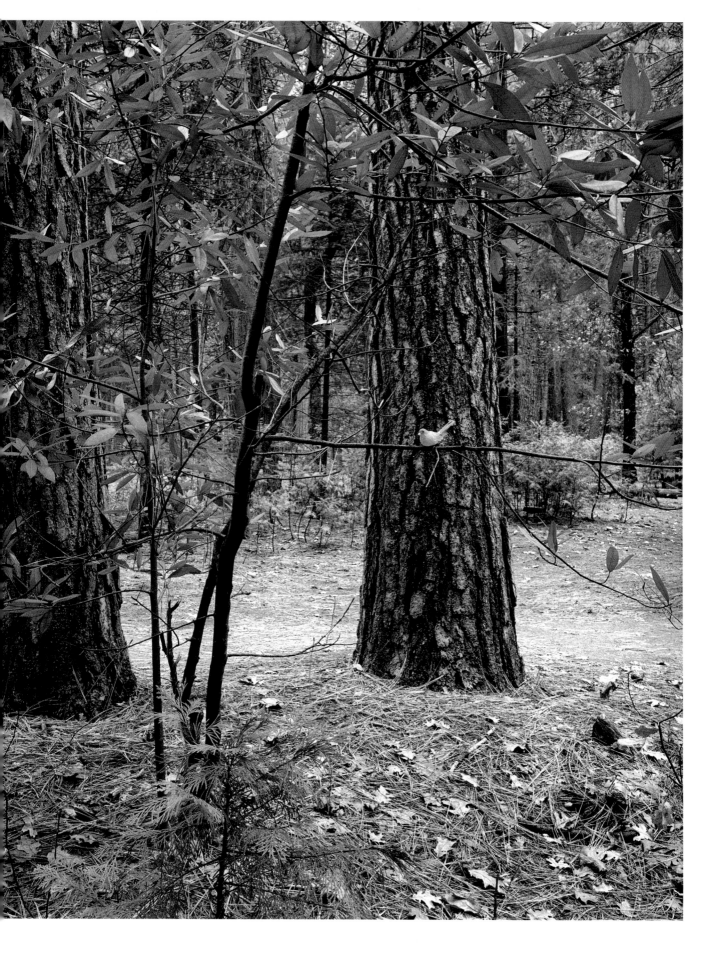

Name	WINTER BLUEBIRDS
Location	Interlochen, MI
Date	December 2007
Size	7 inches
Coloring	Medium-blue bodies, white bellies
Remarks	Despite heavy snowfall, these birds frolic on bare winter branches.

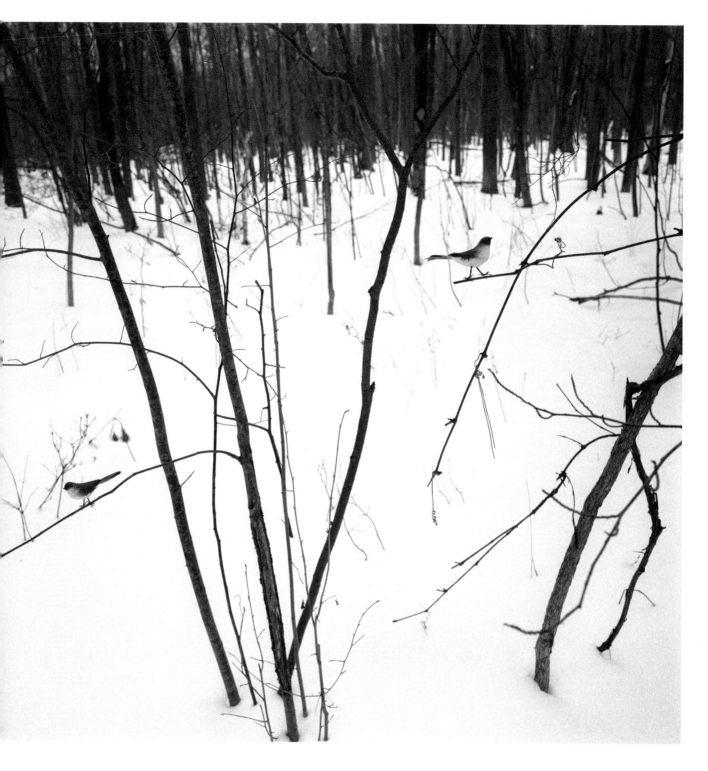

The tiny flowers of Forget-Me-Nots
(common name: Bluebird)
have been said to cure melancholy
when steeped in ale or wine.

Notes: <u>Winter 2007</u>

<u>The year began and ended with heavy</u>
<u>snowfalls. After recording two Green-</u>
<u>capped Buntings in our backyard tree,</u>
<u>I abandoned my observations until</u>
<u>months later when I saw a beautiful</u>
<u>Blue-hooded Cuckoo. It was in the same</u>
<u>tree, nearly in the same spot as the</u>
<u>buntings, on a branch that had just</u>
<u>begun to bud, promising spring.</u>
<u> Sometimes the birds are where I least</u>
<u>expect them, like a Yellow Warbler</u>
<u>summering in South Carolina, which I</u>
<u>encountered on a trip to Charleston,</u>
<u>or a pair of Barn Swallows resting in</u>
<u>a pile of brush. I can't believe the</u>
<u>rare world I am experiencing. I am</u>
<u>amazed at how closely I can watch</u>
<u>these birds if I'm patient, and how,</u>
<u>in some instances, they seem to also be</u>
<u>watching me. I love interacting with</u>
<u>them in the landscape.</u>

In the summer I escaped my rural environment to visit the tropics of Hawaii. I was equally captivated with the lush, tropical foliage of the tree ferns with their gigantic leaves as I was with the birds I spotted there. However, the Tropic Warblers with their white bodies and red beaks were quite an unusual find.

The last birds I photographed this year are my favorite so far - two Winter Bluebirds. They were jauntily perched in the trees outside my cabin one frosty day. These were two of the few passerines I saw once the snow fell, but they seemed to be fully enjoying the weather, which is more than I could say for myself.

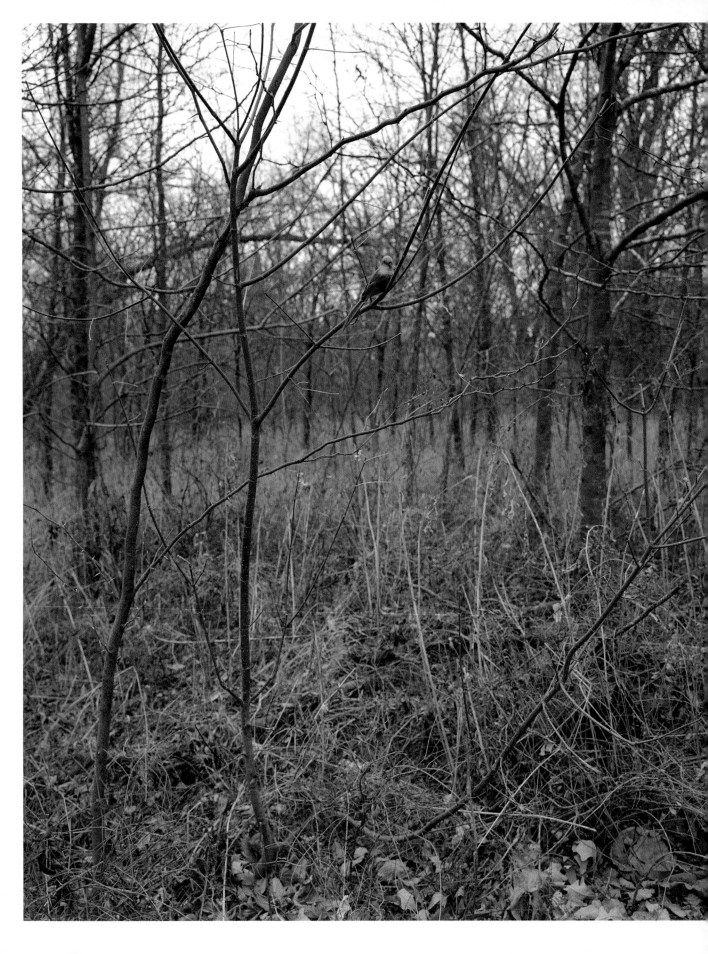

Name	OLIVE - CAPPED FLYCATCHER
Location	Minneapolis, MN
Date	March 2008
Size	8.5 inches
Coloring	Green crown, orange breast, and brown body
Remarks	Found elegantly resting on a curved branch enjoying the crisp day

Name	AMERICAN GOLDFINCHES
Location	MINNEAPOLIS, MN
Date	APRIL 2008
Size	5 inches
Coloring	Black foreheads, golden-yellow bodies
Remarks	Two birds relax on a branch, enjoying the spring sun.

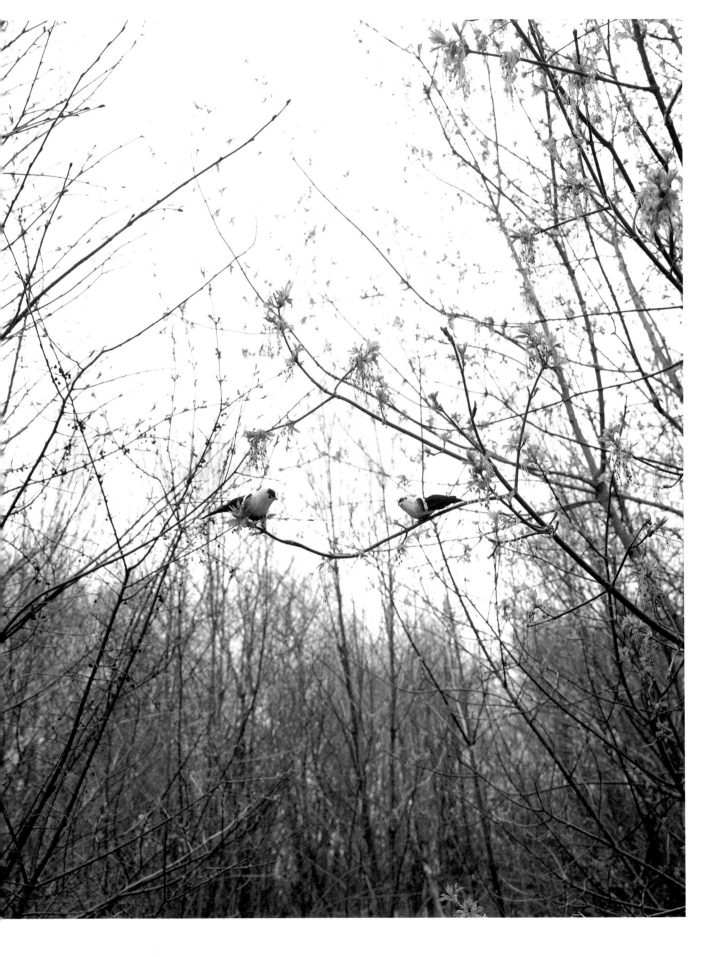

Name	BLUE-CROWNED VIREO
Location	St. Paul, MN
Date	April 2008
Size	5.75 inches
Coloring	Blue crown, white eye band, and green throat
Remarks	Its feathers match the spring leaves and the cool water of the Mississippi.

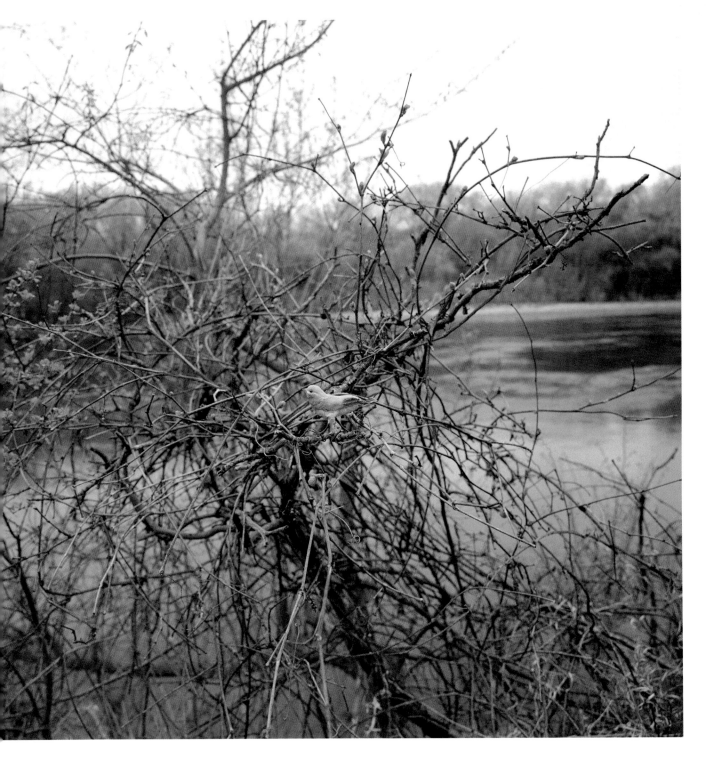

Bird Grass

Its common name is Knotweed.
The weed thrives in dense soil,
but its origins are uncertain.

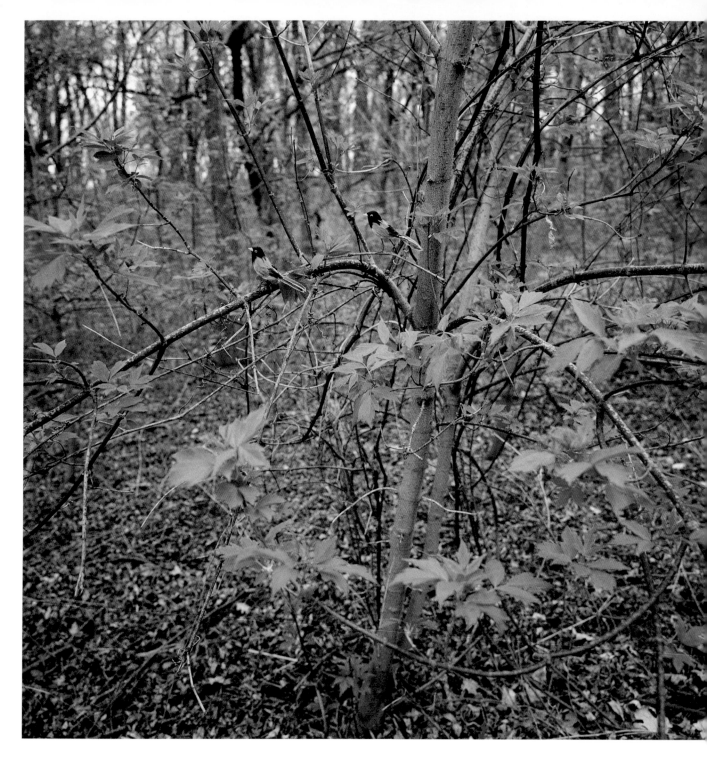

Name	BALTIMORE ORIOLES
Location	Minneapolis, MN
Date	May 2008
Size	8.75 inches
Coloring	Black hood and orange back
Remarks	Active and alert in the fresh spring air

Name	WHITE-BREASTED ORIOLE
Location	Pensacola, FL
Date	July 2008
Size	9.5 inches
Coloring	White breast and black primaries
Remarks	A rare spotting in a subtropical area of the Florida Panhandle

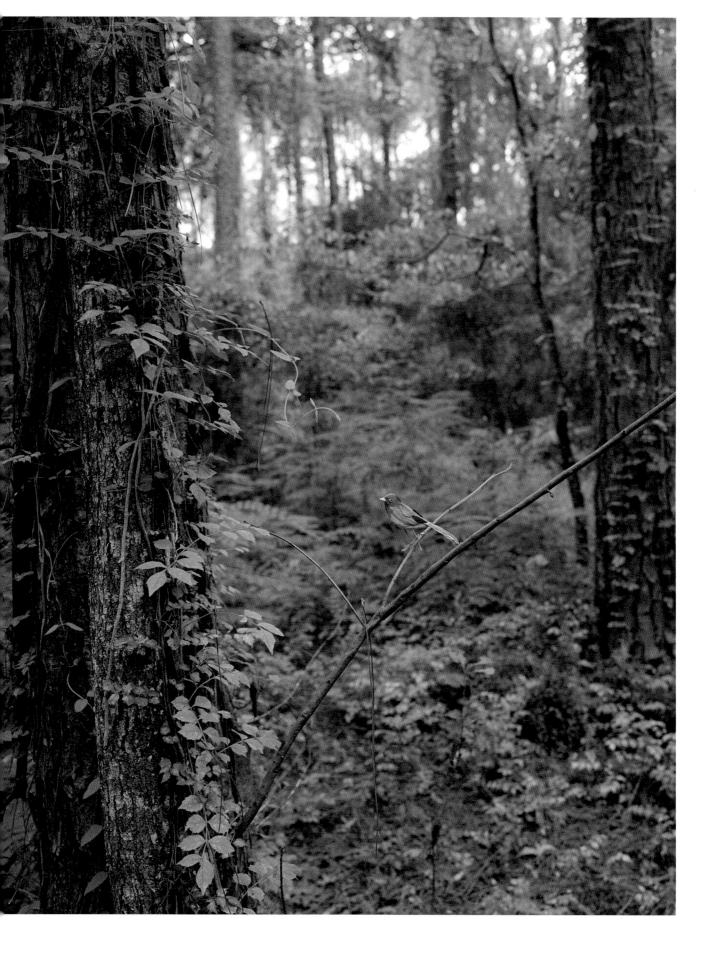

Name	SUMMER TANAGERS
Location	Pensacola, FL
Date	JULY 2008
Size	7 inches
Coloring	Red all over
Remarks	One of the few mono-chromatic passerines

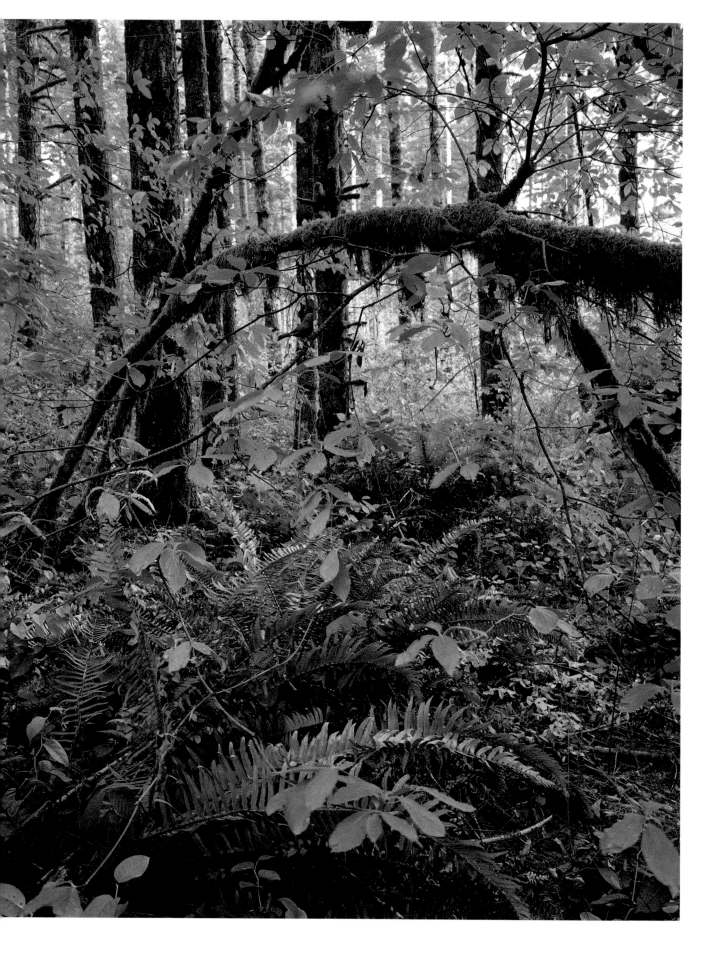

Unidentified ferns collected where
I documented the Summer Tanagers

Name	AQUA TANAGER
Location	San Francisco, CA
Date	August 2008
Size	7.25 inches
Coloring	Aqua crown and coverts, white belly
Remarks	This tanager stopped and patiently posed for his portrait.

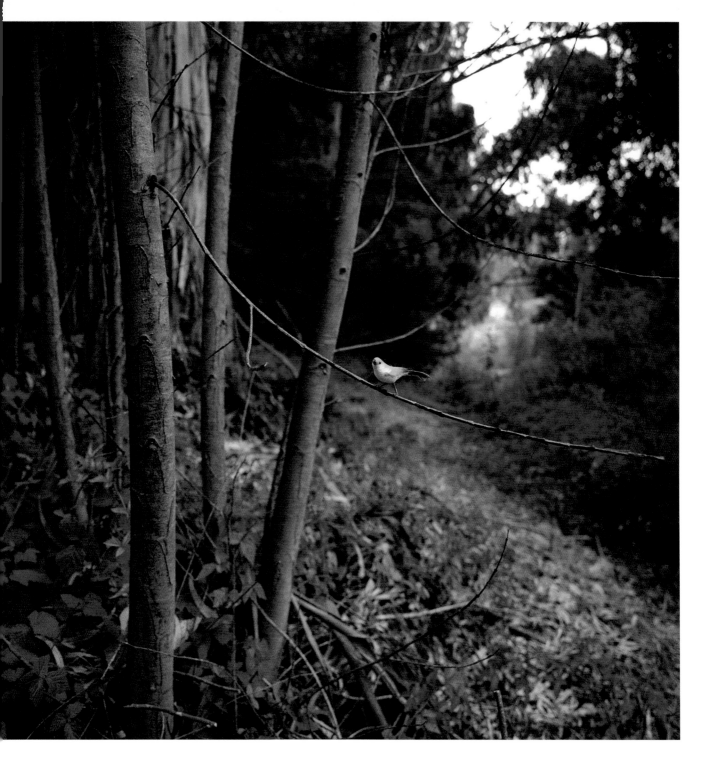

Name	GREEN-HOODED BANDITS
Location	Minneapolis, MN
Date	September 2008
Size	6 inches
Coloring	Green heads with black eye bands
Remarks	These sneaky birds try to hide in the tangled brush.

next page

Name	SPOTTED-BACK THRUSH
Location	St. Croix Falls, WI
Date	October 2008
Size	7.75 inches
Coloring	Bold spots on scapulars
Remarks	Strutting along a curved branch

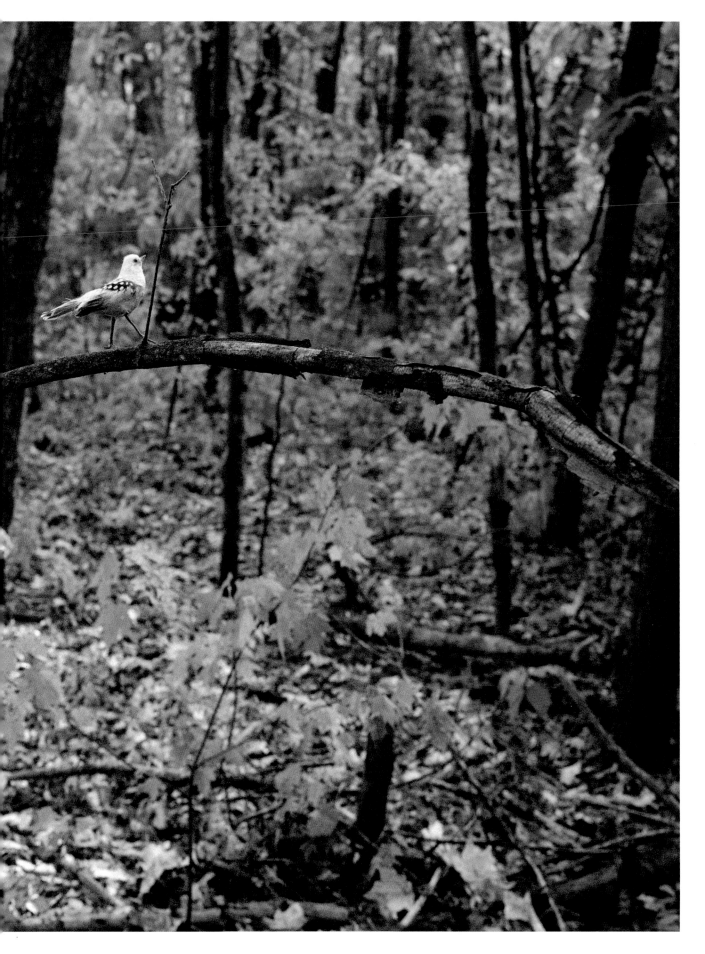

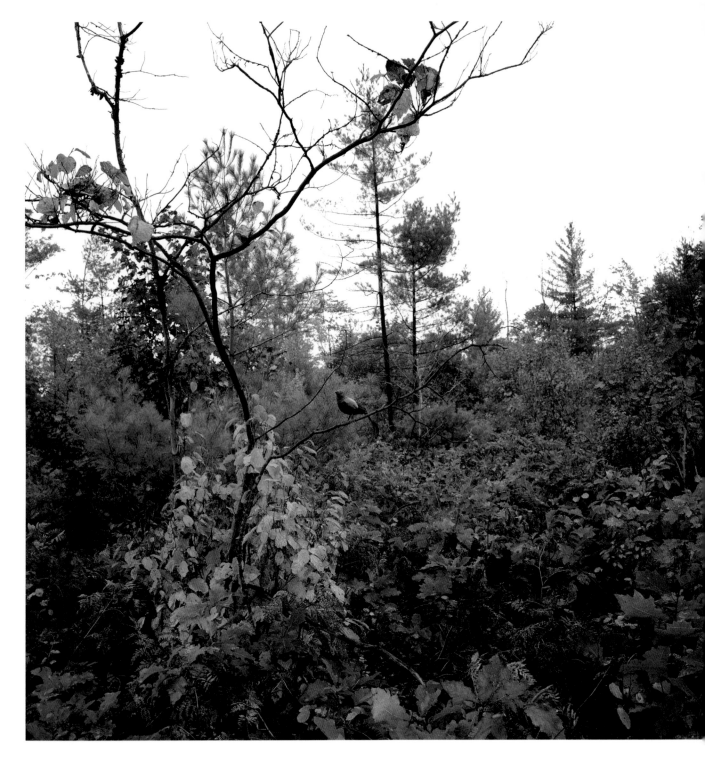

Name	LONG-TAILED WAXBILL
Location	Frontenac, MN
Date	November 2008
Size	10 inches
Coloring	Green crown, burgundy belly, long tail feathers
Remarks	Watching the leaves change

Name	BREWER'S BLACKBIRD
Location	St. Paul, MN
Date	December 2008
Size	9 inches
Coloring	All black
Remarks	Standing guard at the entrance to a wooded creek bed

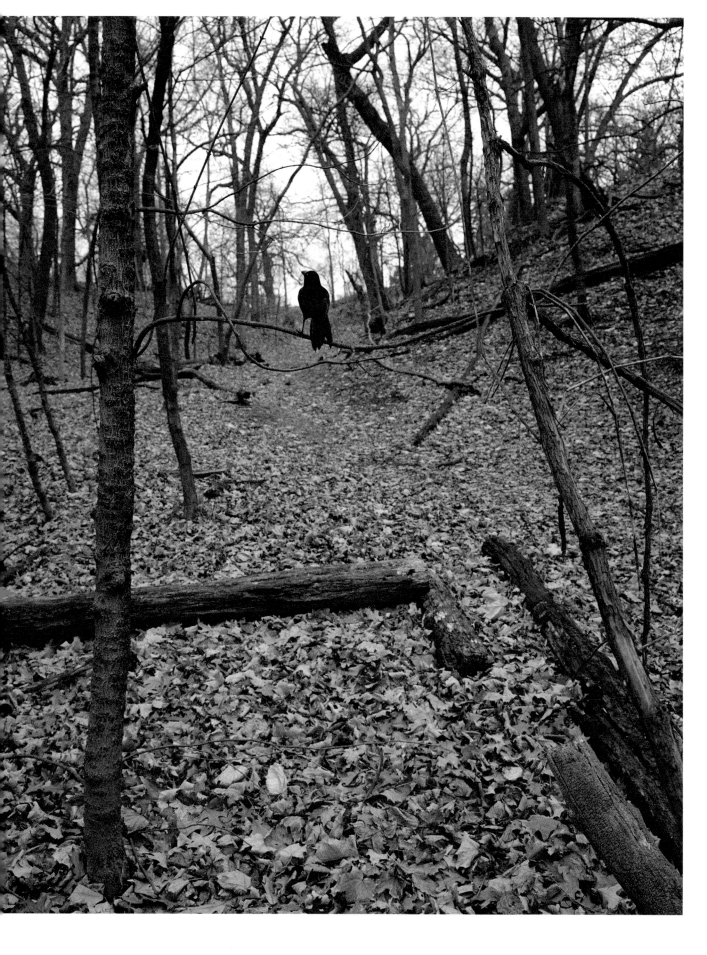

<u>Winter 2008</u>

Since we moved to Minneapolis at the beginning of the year, I've been exploring the landscape around the Mississippi River, a short walk from my house. The river is the longest of the North American migration flyways, stretching three thousand miles from Arctic Alaska to the Gulf of Mexico.

Once the snows melted, I saw an Olive-capped Flycatcher, whose body blended in with the bare trees and dried leaves on the ground. However, its orange breast foreshadowed the bright colors of the spring birds I would soon encounter. A few months later, two Baltimore Orioles nearly leaped from the newly green spring leaves on a tree branch along the river. Similarly, a pair of American Goldfinches' bodies mirrored the bright, warm sun.

Notes:

 By now I have become so comfortable approaching the birds, they seem to hold their poses for me as long as I need them to in order to make their portraits. I think some even show off a bit, like the Spotted-back Thrush that strutted along a bent branch in profile, displaying his beautifully spotted mantle.

 After all this time photographing the birds, I'm happy to have been able to really examine them, instead of getting mere glimpses as they hide just out of view. I'm ending this collection with a Brewer's Blackbird, perched perfectly on a branch that balanced between two trees. This image is an apt representation of my three-year collaboration with the natural world.

Life List

as of December 2008

 Northern Cardinal

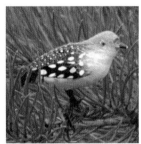 Spotted Wren

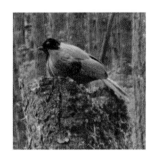 Western Bluebird

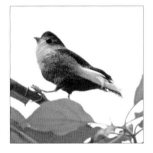 Black-capped Chickadee

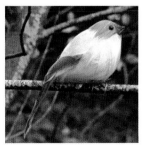 Gray-headed Chickadee

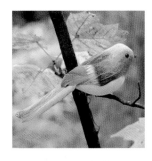 Orange-throated Phoebe

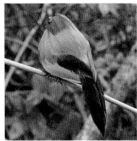 Chestnut-backed Chickadee

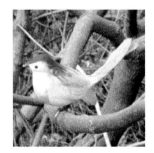 Pink-tailed Gnatcatcher

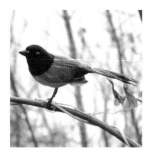 Dark-eyed Junco

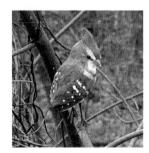 Blue Jay

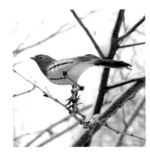 Song Sparrow

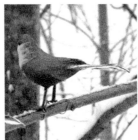 Green-capped Bunting

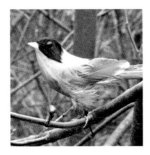 Blue-hooded Cuckoo

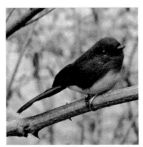 Vermilion Flycatcher

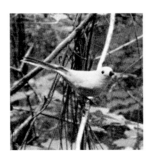 Yellow Warbler

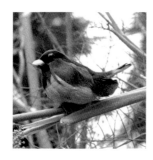

California Wren

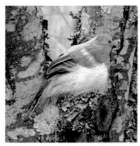

Grassland Sparrow

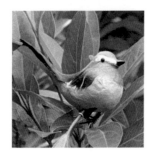

Pacific Mockingbird

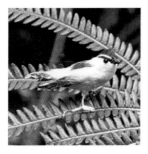

Tropic Warbler

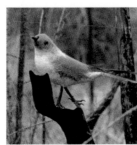

Orange Thrush

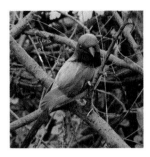

Barn Swallow

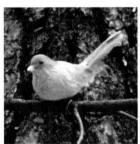

Northern Vireo

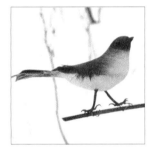

Winter Bluebird

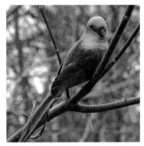

Olive-capped Flycatcher

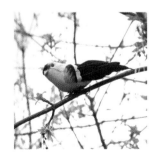

American Goldfinch

103

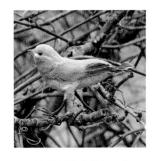

Blue-crowned Vireo

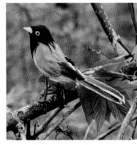

Baltimore Oriole

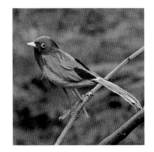

White-breasted Oriole

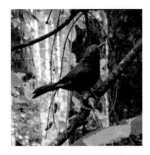

Summer Tanager

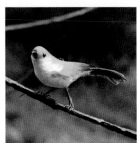

Aqua Tanager

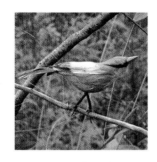

Green-hooded Bandit

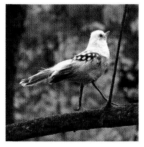

Spotted-back Thrush

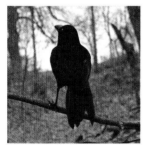

Long-tailed Waxbill

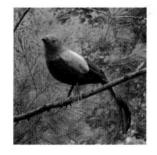

Brewer's Blackbird

Parts of a Passerine

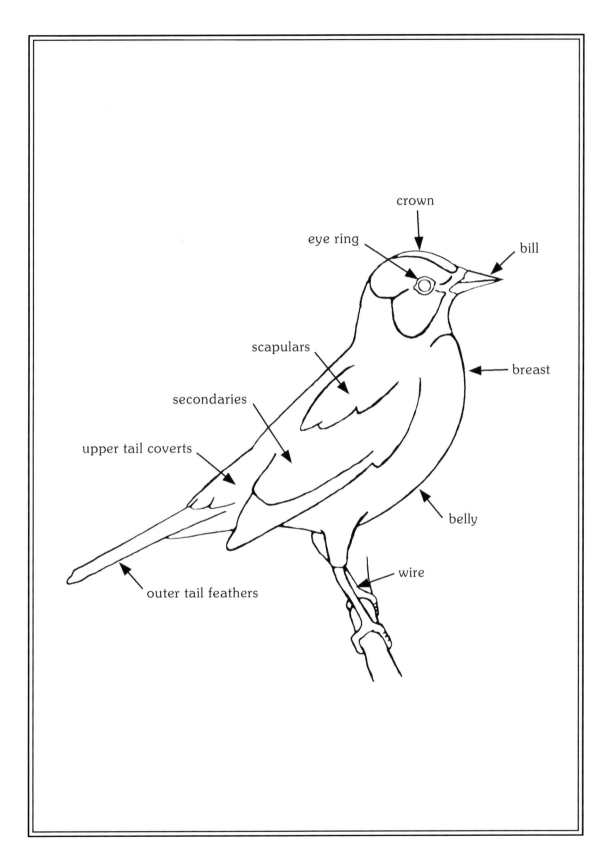

crown

eye ring

bill

scapulars

breast

secondaries

upper tail coverts

belly

outer tail feathers

wire

State Birds
(and where I spotted the same species)

 Baltimore Oriole – Maryland (Minnesota, Florida)

 Bluebird – Missouri, New York (Montana)

 Blue Hen Chicken – Delaware

 Brown Thrasher – Georgia

 Cactus Wren – Arizona

 California Seagull – Utah

 California Valley Quail – California

 Cardinal – Illinois, Indiana, Kentucky, North Carolina, Ohio, Virginia, West Virginia (Oregon)

 Chickadee – Maine, Massachusetts (California, Michigan)

 Common Loon – Minnesota

 Eastern Brown Pelican – Louisiana

 Eastern Goldfinch – Iowa, New Jersey

 Great Carolina Wren – South Carolina (Oregon, California)

 Hermit Thrush – Vermont (New Mexico, Wisconsin)

 Lark Bunting – Colorado

 Mockingbird – Arkansas, Florida, Mississippi, Tennessee, Texas (Hawaii)

 Mountain Bluebird – Idaho, Nevada (Michigan)

 Nene – Hawaii

 Purple Finch – New Hampshire

 Ring-necked Pheasant – South Dakota

 Rhode Island Red – Rhode Island

 Roadrunner – New Mexico

 Robin – Connecticut, Michigan, Wisconsin

 Ruffed Grouse – Pennsylvania

 Scissor-tailed Flycatcher – Oklahoma (Minnesota)

 Western Meadowlark – Kansas, Montana, North Dakota, Nebraska, Oregon, Wyoming

 Willow Goldfinch – Washington (Minnesota)

 Willow Ptarmigan – Alaska

 Yellowhammer – Alabama

Approximately 700 species of birds
live in the United States, and
about 385 are passerines,
or perching birds.

Migration Patterns
of a Bird Watcher

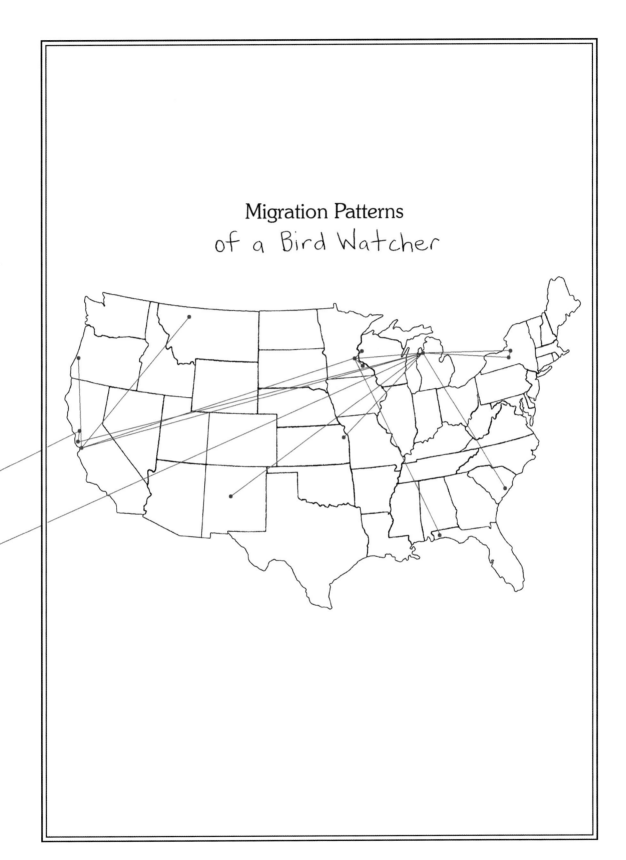

Following Birds

I remember the first bird I shot and killed. It was a starling, a noisy but elegant black bird that can be seen peppering lawns throughout the Midwest during the early morning and late afternoon hours. I was ten.

I also remember the sick feeling in my stomach the second after I pulled the trigger, as I watched the bird fall silently to the ground, wings folded against its side. I dropped my grandfather's Daisy BB gun, rushing to where the bird had landed, near a tree fifty yards away. The starling was utterly beautiful, a wonder of creation. But really, what bird isn't? Layers upon layers of feathers serve as both their costume and their means of transport—a perfect marriage of beauty and utility. I've read that birds see movement at such a different speed than humans that to them, we look as slow as sloths.

But this starling was no longer a flitting, quick-moving wonder. The body was limp and its head was cocked to the side, its yellow beak polished and bright against the shaded grass under our mulberry tree. I didn't quite know what to do, as I hadn't really thought I would hit it. My emotions were a stew—I was proud that I had actually hit my target from so far away, but sad to realize I had taken an innocent life. Grandpa announced that we would bury it where it had fallen, under the tree and along the fencerow, beyond which lay cornfields that stretched as far as my eye could see—it would be a fitting resting place for this creature. I agreed and rushed to get the hand shovel out of the shed with as much determination as I'd had when taking aim at the bird.

That starling was also the last bird I shot. It was, however, far from the last bird I killed. It is estimated that over sixty million birds are killed by motor vehicles every year in the United States alone, a figure further compounded by the hundreds of millions of birds that household pets, namely cats, kill each year.[1] Hundreds of millions! These are staggering figures, and I estimate that through cars and cats, I have killed or enabled the killing of at least a good several dozen birds. That's probably letting myself off easy.

I grew up in the farmlands of Iowa, where the fences, barns, and treetops are filled with the chirps and cackles of starlings, purple martins, robins, blue jays, mourning doves, the occasional finch, and the ever-present sparrow. My favorite was always the red-winged blackbird, a glossy black bird aptly named for the bright red rectangular patch on its wings. I was an avid book reader as a child, diving into encyclopedias, maps, and anything that had to do with the Loch Ness Monster or Bigfoot. I also had two pocket field guides that I thoroughly dog-eared during my childhood: the National Audubon Society's *Field Guide to North American Insects and Spiders* and its *Field Guide to North American Birds*. I remember poring over the photographs in these books while trying not to touch any of the pictures of spiders, which creeped me out. All of the subtle differences between the male and female birds were a curiosity to me; I studied the plumage and colorings of each, wondering what purposes they served.

But the photographs in these field guides were decidedly lame. Even at ten years old, I knew that much. They were all too straightforward, too head-on, or too oblique. The depth of field was so shallow that the out-of-focus foreground oftentimes obscured the birds, and overall the photographs reeked of a weird hunting sentimentality. The images—which were either small thumbnails or tightly cropped slices with lots of verbal detail surrounding them—seemed completely boring then, as they do now. I wanted better images, and even at that young age I knew that somehow this could be accomplished.

I knew it had been accomplished when I saw Paula McCartney's photographs in *Bird Watching*. I was overcome with a sense of joy. Here were birds—beautiful, gorgeous creatures—set amidst the stunning landscapes of their natural habitat. "Thank God!" I thought. "Finally someone has pulled it off." These are pictures of birds the way they're supposed to be seen—in well-rendered and compositionally balanced landscapes that showcase the birds like the jewels they are. By the third

or fourth page, however, I began to suspect that something was up, something was being played with, and that it might just be me. I leaned in and realized that the stiff-legged, perfectly colored, unruffled birds are actually inanimate objects. These birds are fake!

And yet, they are exactly as they should be, exactly as they had been for years in my mind's eye. The many childhood hours of wandering along ditches and creeks watching birds and squirrels and grazing cows had left me with memories that these photographs evoked and satisfied—they are a perfect distillation of those bygone years.

Both photography and memory are slippery. They toy with our understanding of what is true and what is false. A photographic image of one's family is just that—a photographic image. It is not one's family, but simply a reminder, a representation of a fraction of a second on one particular day when one was wearing a certain set of clothes and donning a frozen set of expressions. The photograph is a powerful talisman, a symbol that can conjure up the full range of human emotions. But it is not the real thing.

What guidebooks attempt is a feat of near impossibility. They try to give us as much information about the real thing as possible without actually giving us the real thing. They are scientific in their attempt at physical exactitude. What science gives us, however, is, at best, an elegant description of a partial truth.

McCartney's photographs also try to give us the real thing, at least up to a point. Her images evoke the reality and beauty of the underbrush where many of the midwestern birds in her photographs are found. Even though she's not actually photographing the birds, perhaps what is missing from the guidebooks can be found in her pictures and what is missing from her photographs can be found in the guidebooks. And all of it can be found in nature. If science is one wing of civilization, then art is the other, to use an apt metaphor.

To be sure, there are lots of real things in McCartney's images. For starters, those are really fake birds. The craft-store dummies— painted Styrofoam with dyed feathers—are out in that landscape because McCartney put them there while she was scrambling through the brush. I like that—she deserves to see a beautiful bird after doing all that work. Surely, she did see some real birds on these outings, but they just didn't let her get close enough to take the kinds of photographs she envisioned—photographs that make you want to hang them on your wall and live with them. These are gorgeous images, and in that sense, they are worthy of their subjects. If only the real birds knew how good McCartney would make them look. But they don't—they fly away. Only the long lens–endowed safari photographer will be able to capture them, making photographs that forever let us down.

McCartney's photographs of fake birds in real settings are also not digitally enhanced. There is no Photoshop going on, which begs the question, "Why not?" She could just as easily have made the exact same photographs, sans fake birds, and cut and pasted in a picture of a live bird, creating (perhaps) a more convincing image. But that's just substituting one fakery for another. And in a certain way, McCartney's photographs seem decidedly more honest. She was there, the fake birds were there, the landscape was there, and she had a camera and film to record it all.

In *Bird Watching*, McCartney takes her life-inspired fantasy to the level of a collection, as any birder does. This is her life list, an album for her grandchildren to pore over and admire. They will look at these landscapes and the fake birds and wonder what she had to do in order to collect so many specimens. "Wow!" they'll think. "How many craft stores did she have to visit? How many hikes did it take to find the perfect setting for that blue jay on page thirty-four? How many rolls of film did she use?" McCartney has created and documented multiple scenes with

as many fake birds as possible, and has lovingly gathered them into a book. This is a record of an involved effort that took place in time and space, recorded for posterity.

We've been trained to think of photographs as documents of things that really happened in the world: that we, through the photographer, are silent witnesses to the forces of life and nature and man. In many ways, this holds true in *Bird Watching*. McCartney was there, and so were those pieces of Styrofoam that look like birds. And while the initial enticement of her images leads to a brief poke in the eye, we are not so stunned as to recoil in disgust. She's not laughing at us by drawing us into her fantasy, rather, she's playfully reminding us that all photographs indulge in certain fictions. And like any good book, she takes us on a journey that is educative and inspiring.

Darius Himes
Writer, photography critic, and founding
member of Radius Books

[1] U.S. Fish & Wildlife Service, *Migratory Bird Mortality* fact sheet, January 2002, www.fws.gov/birds/mortality-fact-sheet.pdf.

Acknowledgments

First, much love and many thanks to Lex Thompson, my husband and colleague, for his love, friendship, patience, advice, and help with all things technical. I can't imagine doing any of this without you and look forward to all our future adventures. My deep appreciation and love goes to my parents, Pat and Rich McCartney, for their encouragement and ever-continuing support of my artistic career.

Thanks to Tana Kellner and the Women's Studio Workshop for supporting and copublishing the original artist book on which this book is based. Many thanks also to Sally Gall, Doug Hall, and Dianne Andrews Hall, friends and artists I have worked for, learned from, and been inspired by. And to Shiva, the real bird watcher.

For his overall passion for photography books, I thank Darius Himes for his excitement about this book, his much appreciated advice along the way, and his personal and poetic essay.

Thank you to Karen Irvine for her smart and insightful introduction to this book and to the Museum of Contemporary Photography for their support of my work through the Midwest Photographers Project and this publication.

Many thanks to Debra Klomp Ching and Darren Ching of KLOMPCHING Gallery for their belief in and support of my work. For their thoughtful advice and encouragement I'm grateful to Toby Jurovics, Michael Foley, Ann Pallesen, Elizabeth Avedon, KayLynn Deveney, Pamela Valfer, Eirik Johnson, Kim Dowazewski-Smouse, Charles Hobson, Jeff Rathermel and the Minnesota Center for Book Arts, Rosemary Furtak at the Walker Art Center Library, and the McKnight Foundation. Thank you to Chris Dickie of *Ag*, Justin Leonard of *(photographs)*, Adrian Lurssen of *Practice: New Writing + Art*, and Gavin Rooke of *6x6* for previously publishing selected images from this series.

And finally, thank you to Jennifer Thompson, who first shared my book idea with everyone at Princeton Architectural Press, and special thanks to my editor Nicola Bednarek and design director Deb Wood.